God Loves You

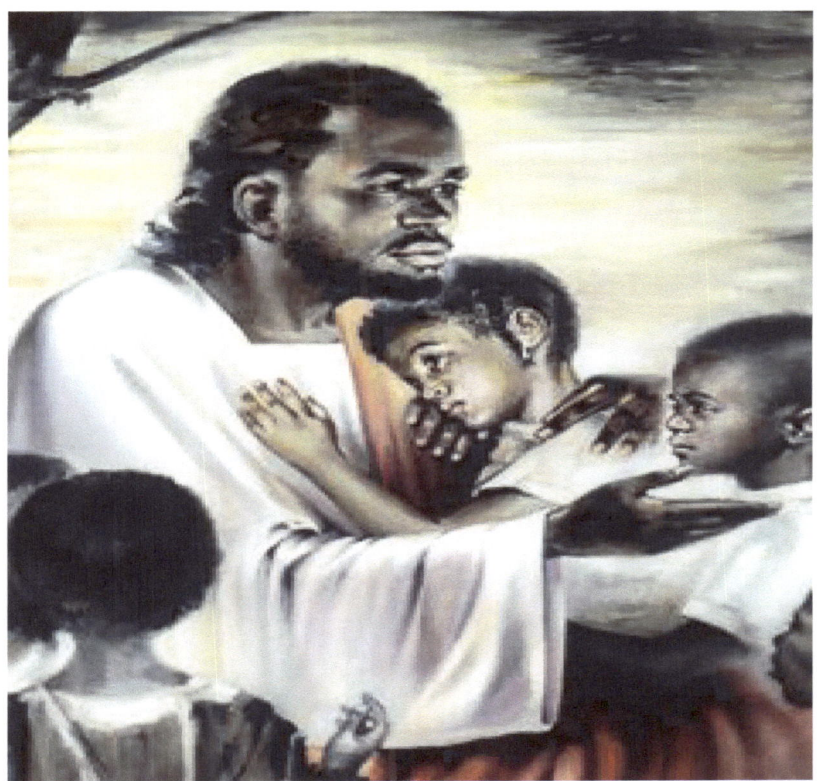

Written By: Melissa L. Bryant

I dedicate this book to my grandchildren. I dedicate this book to all the children around the world.

God loves you no matter what is going on in your life.

It does not matter what color your skin is if you're poor or rich.

He still loves you. God just want us to do right. God bless you all and the best is yet to come.

Author Melissa L. Bryant

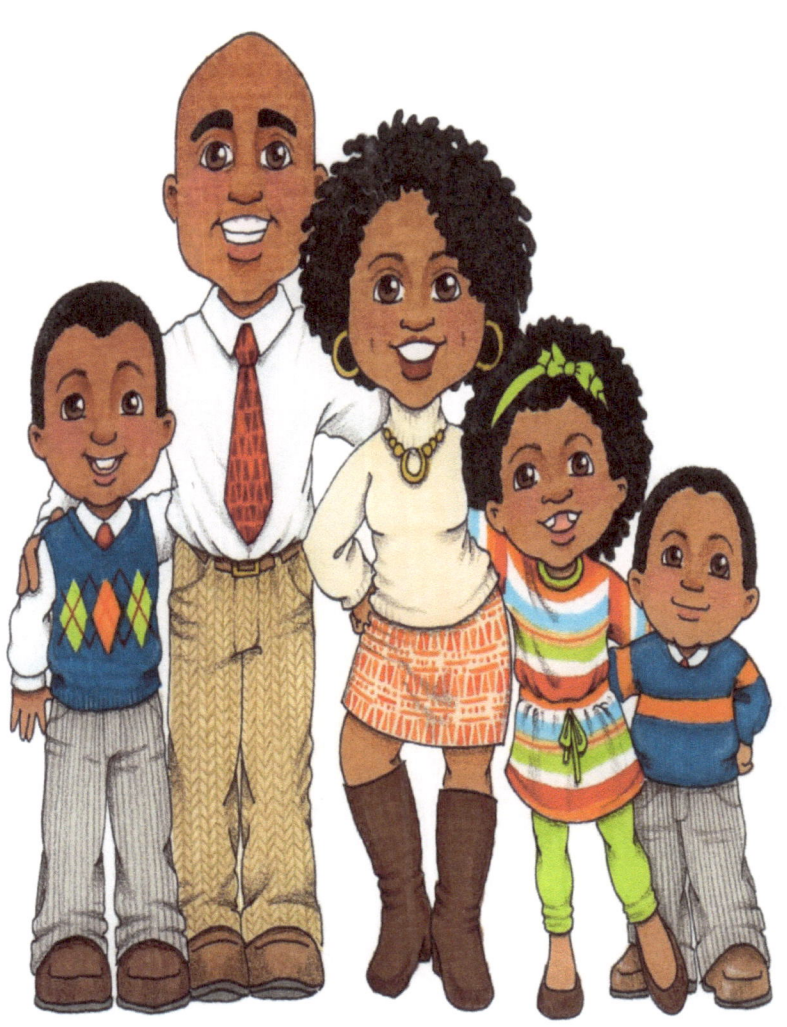

My family is big but, God still loves me.

My family is rich but, God still loves me.

(2.)

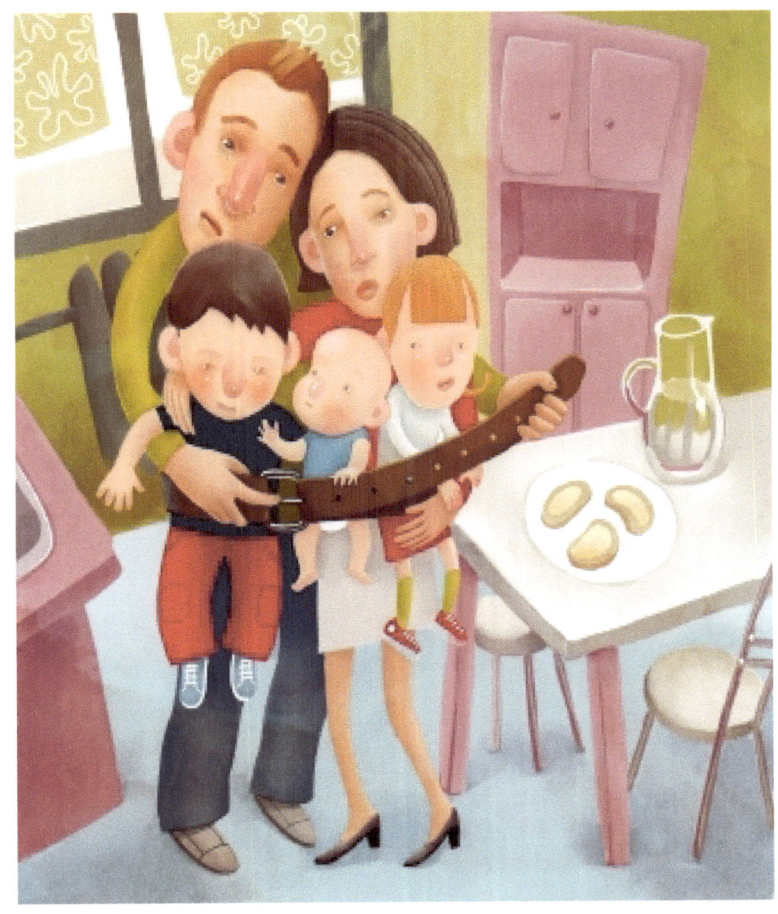

My family is poor but, God still loves me.

(3.)

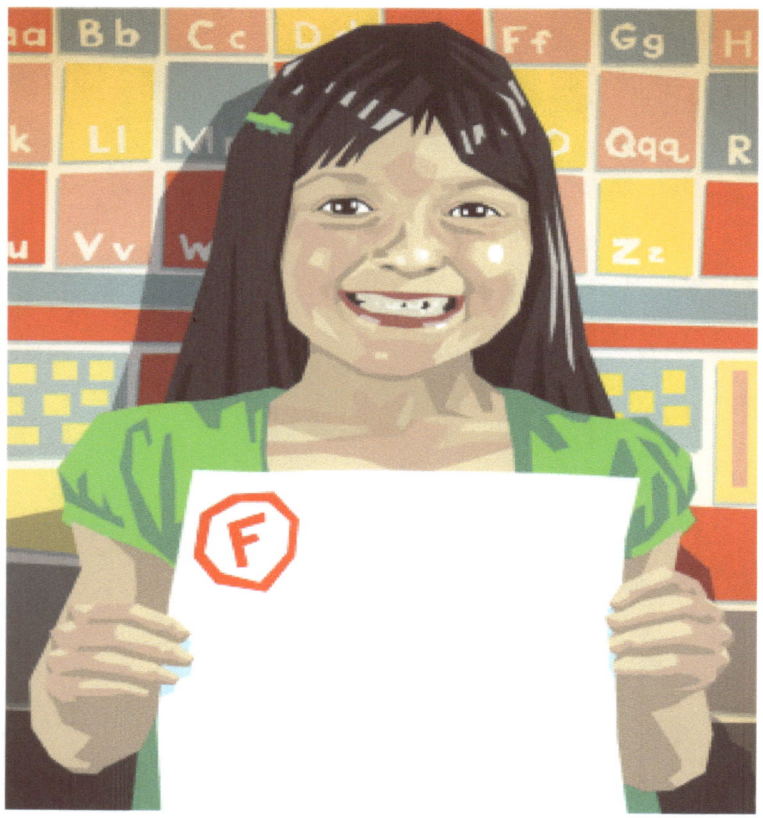

I made a bad grade on my paper but, God still loves me.

I just have to study a little harder.

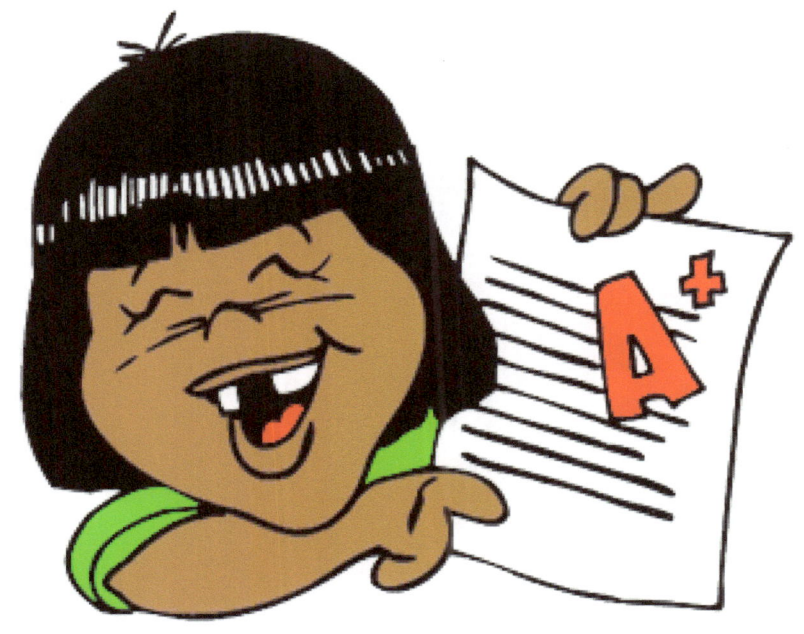

I made an A and God loves me.

My mother is a single parent of two but, God still loves me.

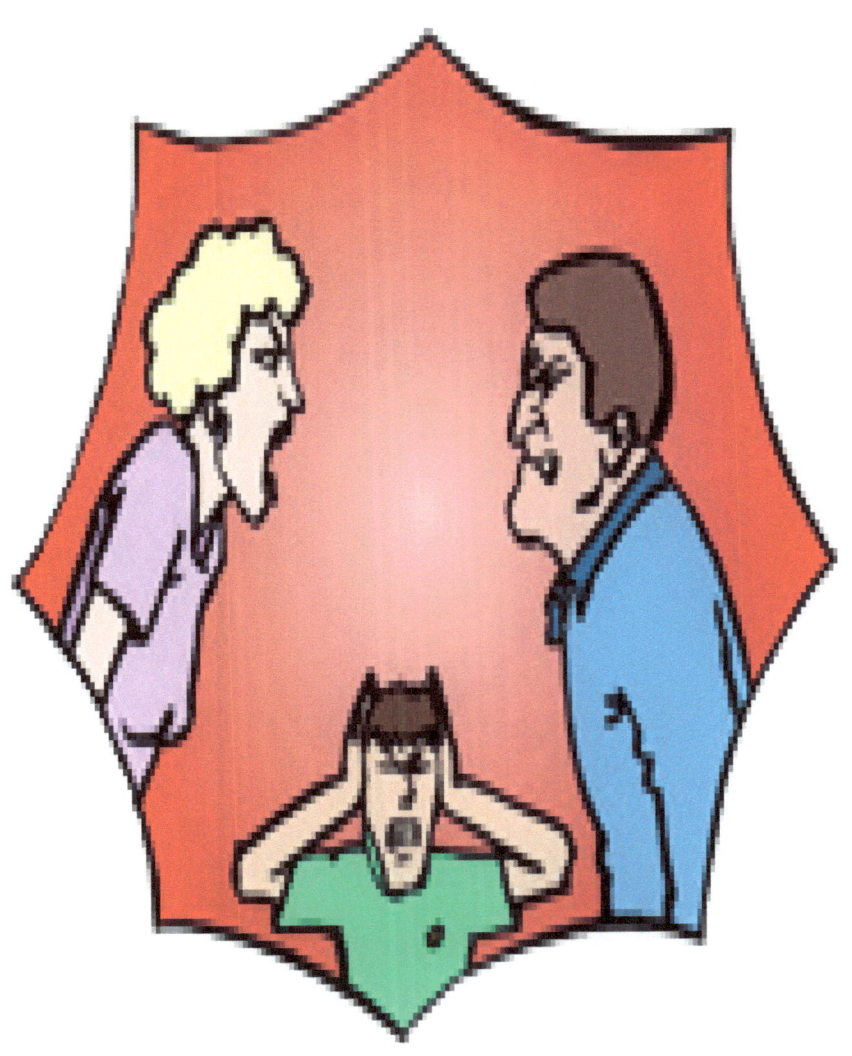

My parents argue all the time but, God still loves me.

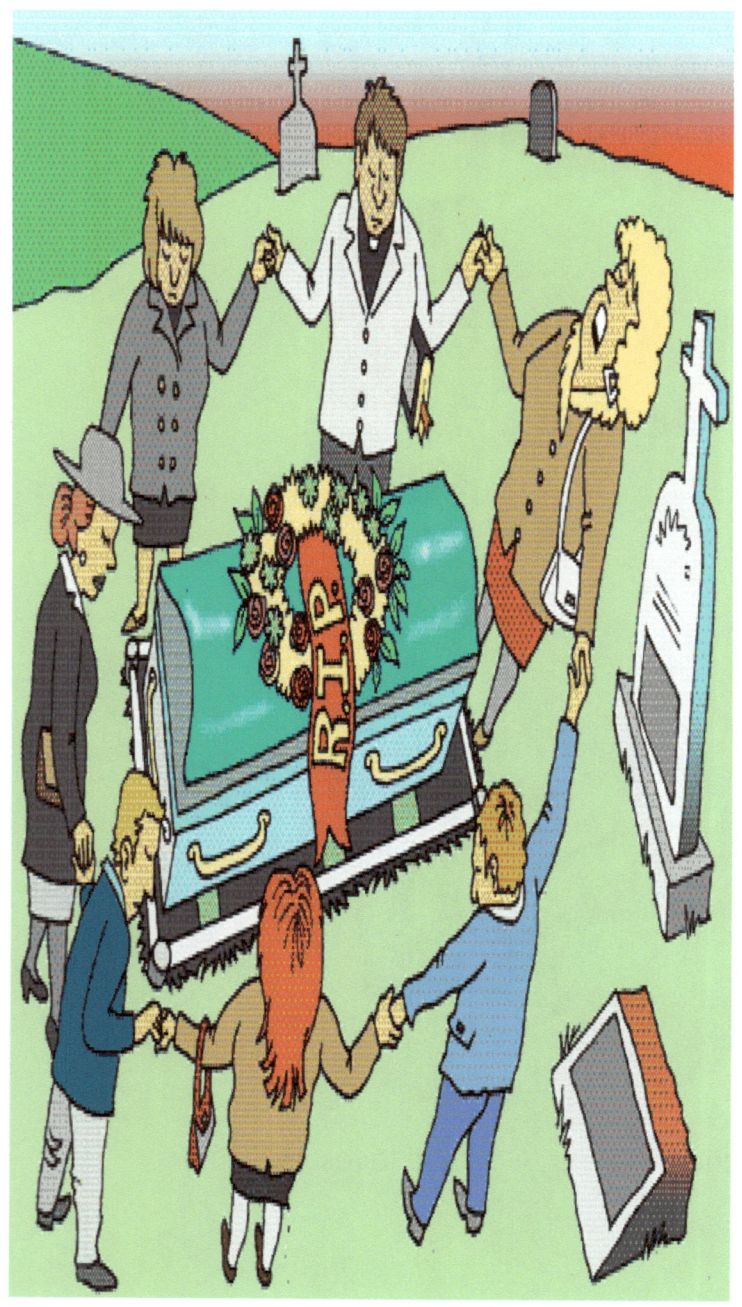

I just lost my father but, God still loves me.

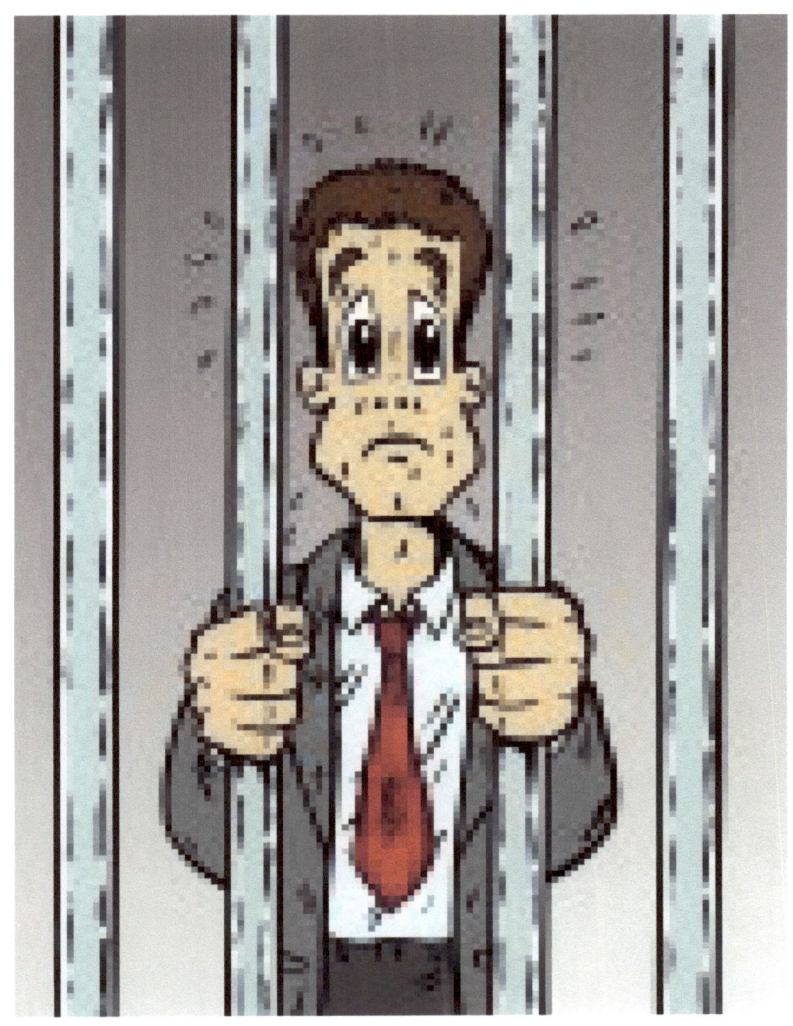

My father is in jail but, God still loves me.

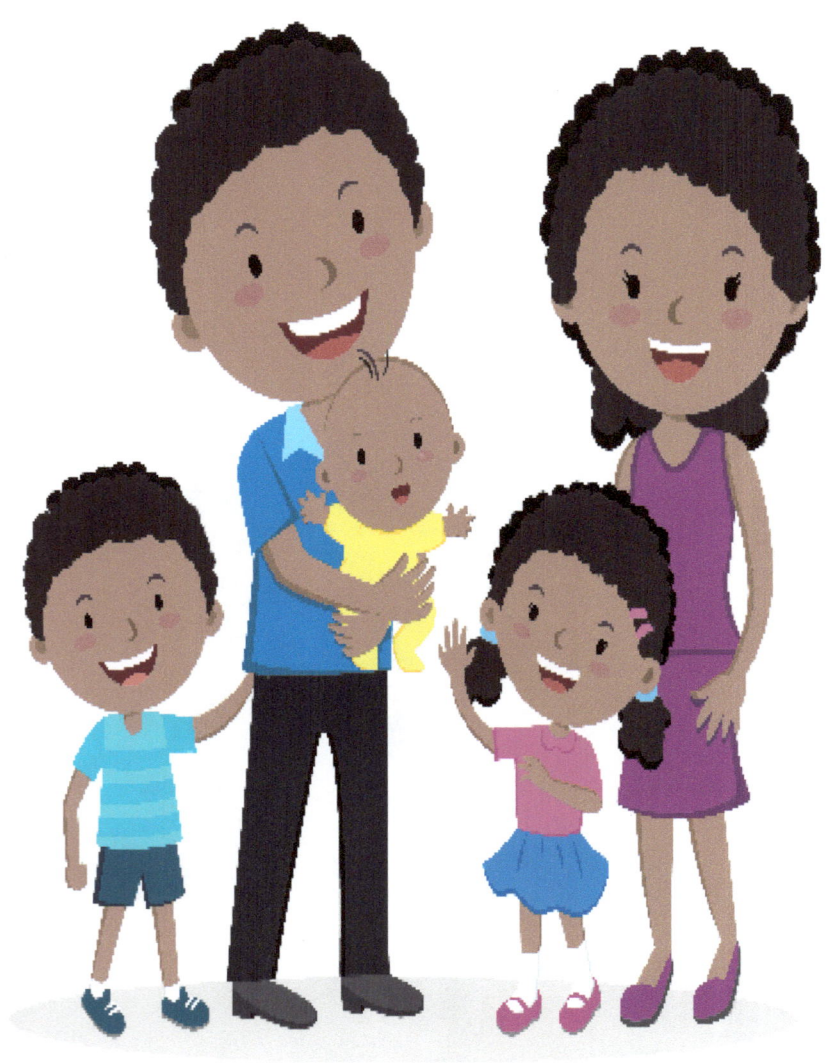

I have foster parents but, God still loves me.

My parents have two jobs but, God still loves me.

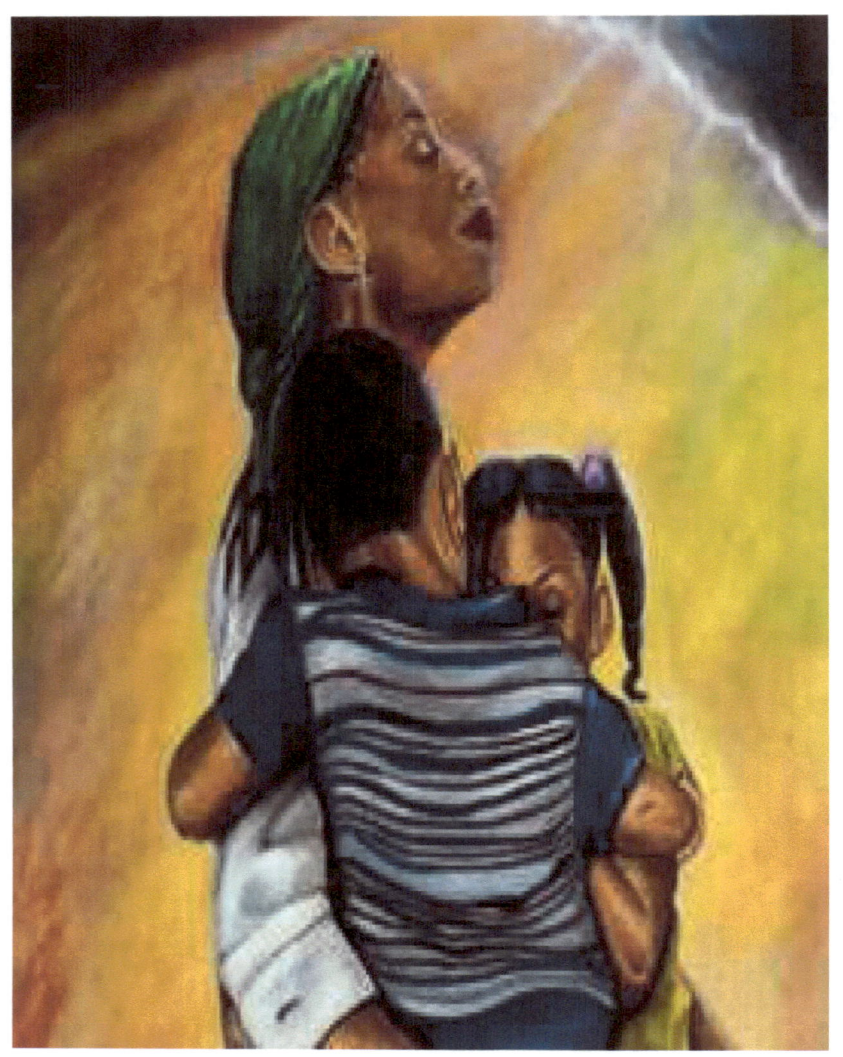

My mother goes to church and father does not but, God still loves me.

We might have a disability but, God still loves us.

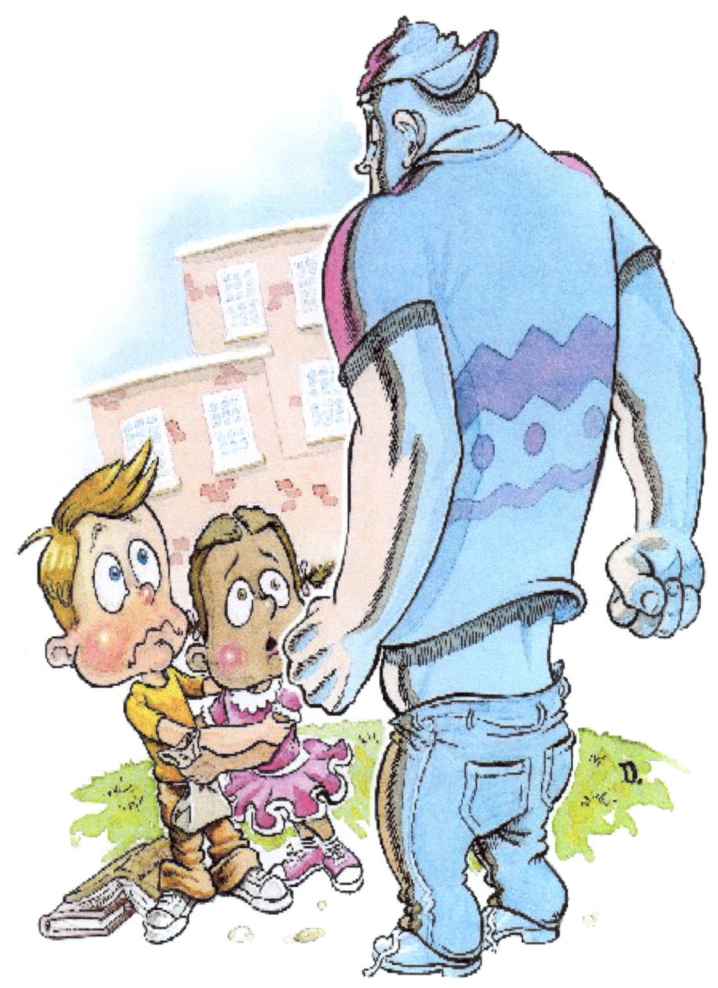

My sister and I are always getting bullied.

It is not fun but, God sees, and he cares.

He forgives you for all your sins. God still loves you.

My father drinks all the time but, still God loves me.

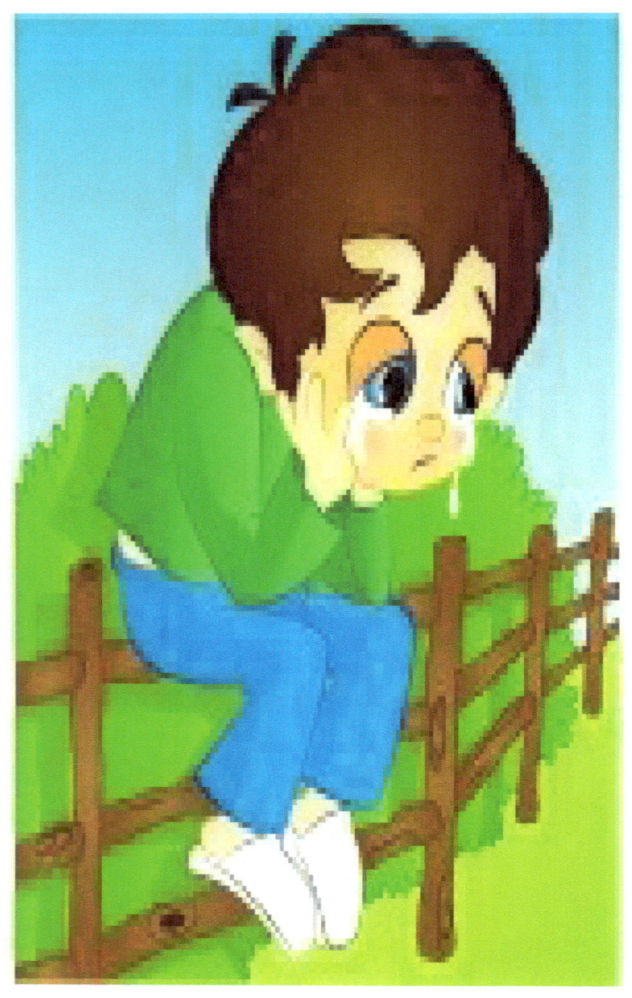

My mother on drugs but, God still loves me.

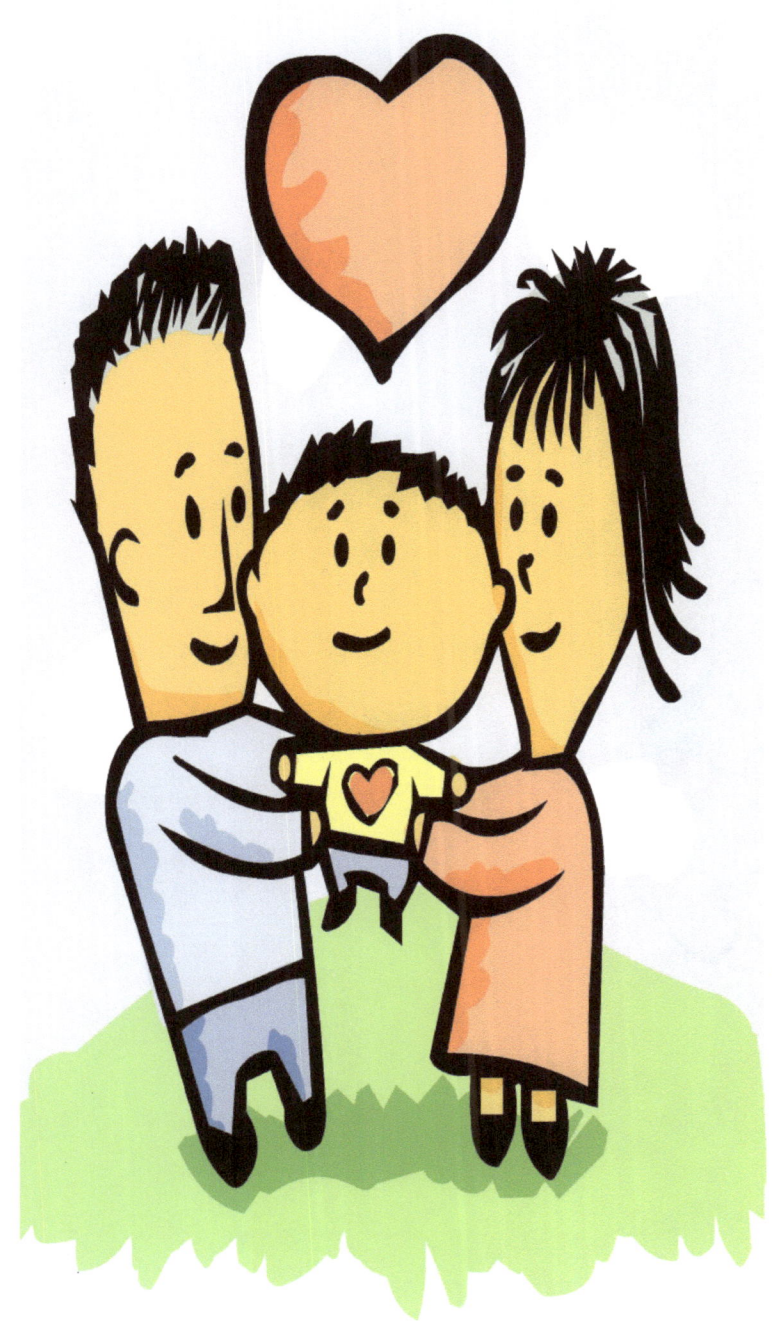

My parents are getting a divorce, but God still love me.

I have Cancer but, God still loves me.

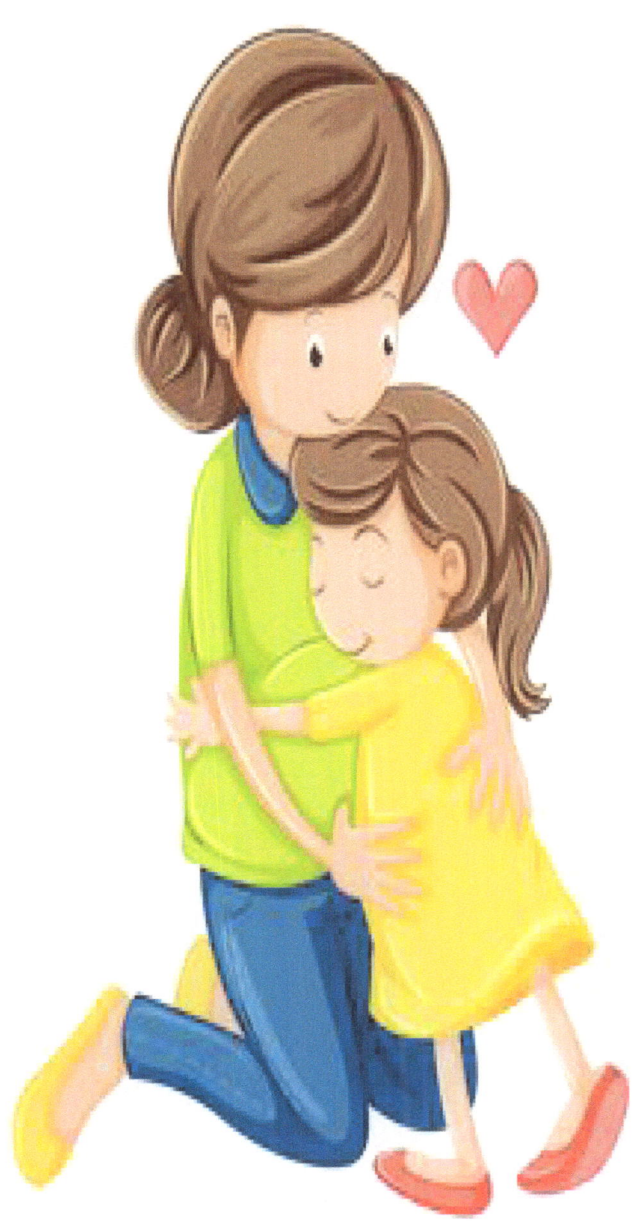

I am the only child but, God still loves me.

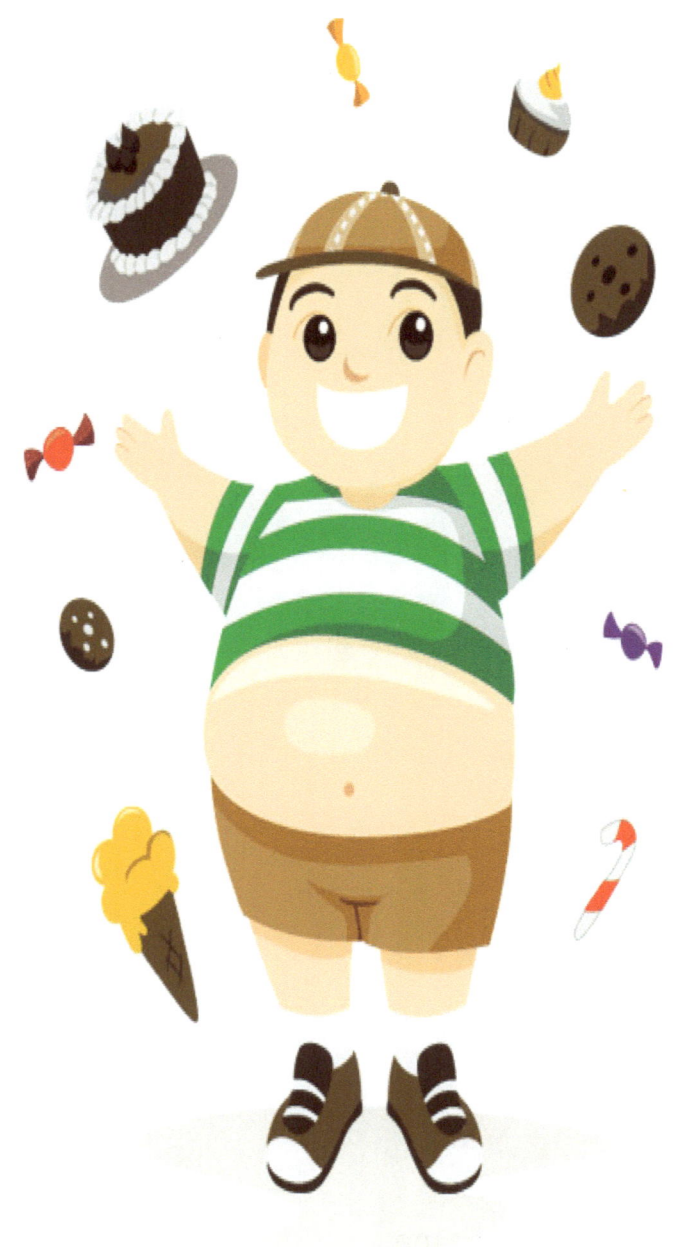

I am big but, God still loves me.

(20.)

I wear glass but, God still loves me.

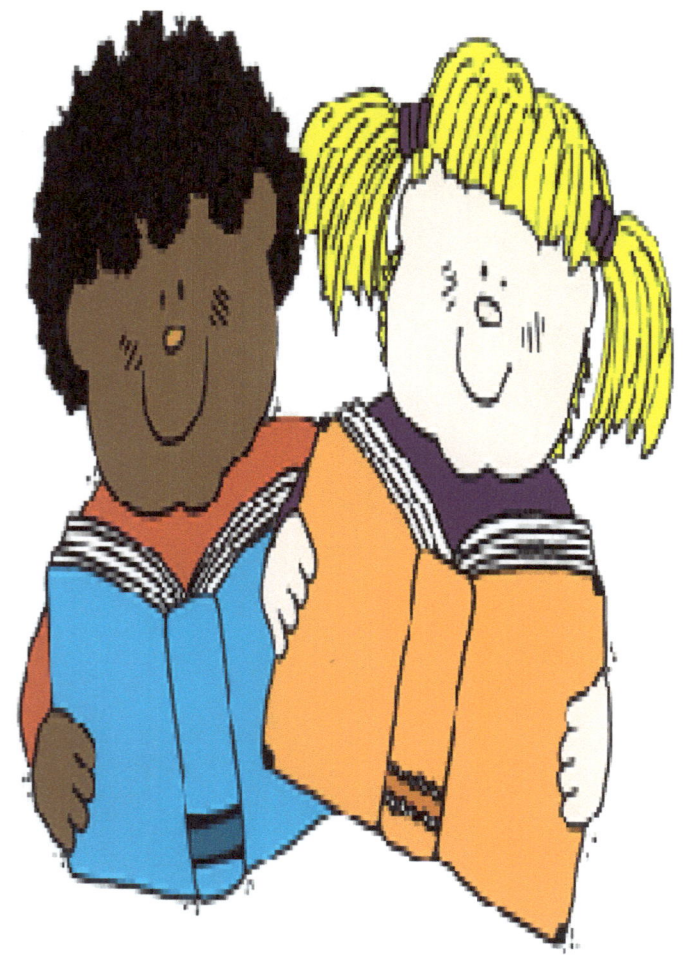

We are assorted colors but, we are best friends and God still loves us.

I have a tough time reading but, God still loves me.

We have braces but, God still loves us.

We are all different but, God still loves us.

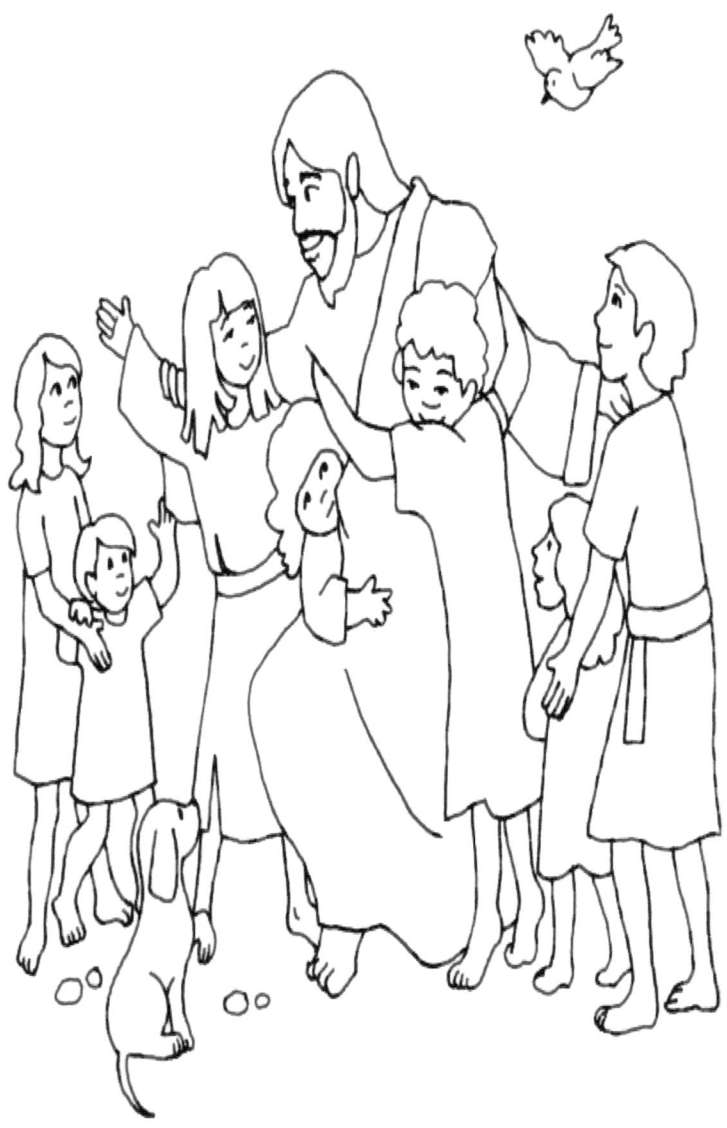

Jesus loves the little children around the world.

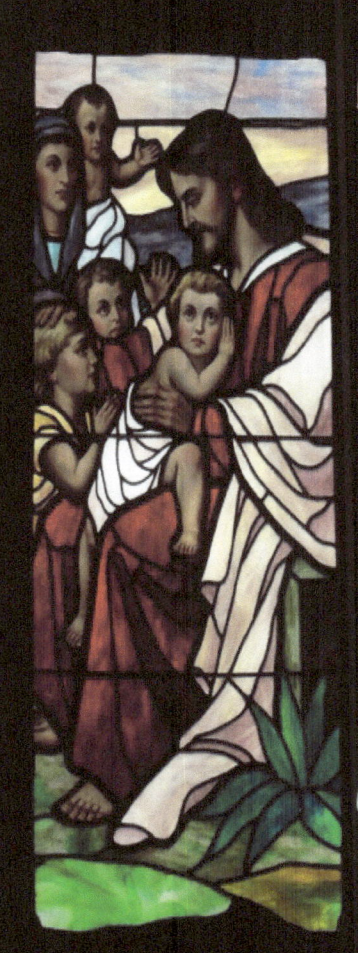

Let the children come unto me, and do not hinder them, for the kingdom of heaven belongs to such as these.

Jesus wept. And they said, "See how he loved him."

God will wipe every tear from their eyes. There will be no more death or mourning, crying or pain.

Matthew 19:14
John 11:35-36
Revelation 21:4

www.ingramcontent.com/pod-product-compliance
Lightning Source LLC
Chambersburg PA
CBHW050415180526
45159CB00005B/2286